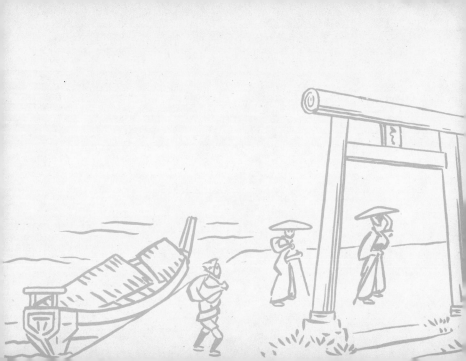

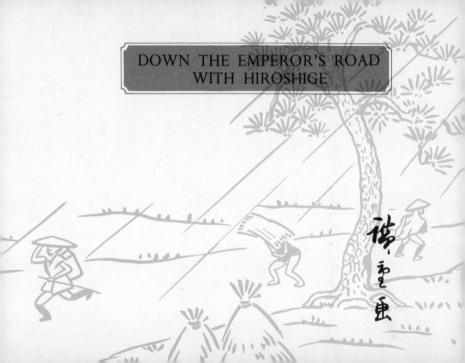

DOWN THE EMPEROR'S ROAD
WITH HIROSHIGE

Representatives

For Continental Europe:
BOXERBOOKS, INC., *Zurich*

For the British Isles:
PRENTICE-HALL INTERNATIONAL, INC., *London*

For Australasia:
BOOK WISE (AUSTRALIA) PTY. LTD.
104-108 Sussex Street, Sydney 2000

Published by the Charles E. Tuttle Company, Inc.
of Rutland, Vermont & Tokyo, Japan
with editorial offices at Suido 1-chome, 2-6, Bunkyo-ku, Tokyo

© *1965 by Charles E. Tuttle Company, Inc.*

Library of Congress Catalog Card No. 65-18959

International Standard Book No. 0-8048-0143-6

First edition, 1965
Ninth printing, 1979

PRINTED IN JAPAN

DOWN THE EMPEROR'S ROAD WITH HIROSHIGE

edited by
Reiko Chiba

CHARLES E. TUTTLE CO.
Rutland, Vermont
& Tokyo, Japan

PREFACE

We have taken the liberty of calling the Tokaido—Japan's most famous highway—the Emperor's Road. Built in 1603, it joined Kyoto—residence of the Emperor—and Edo (today's Tokyo), seat of the executive government of the shoguns. From Edo the Tokaido follows the Pacific coast, hugging the mountains that come right down to the sea. Then it turns inland across a mountain range, passes Lake Biwa, and so ends at Kyoto. The scenery is magnificent.

The constitution of Tokugawa Japan demanded that all daimyo visit Edo once a year, and that their families stay in the city at all times—an effective deterrent to misbehavior in the provinces. On every main road the almost regal processions of these feudal barons were a familiar sight. Along the Tokaido journeyed the lords of the western provinces, as well as a constant stream of couriers between the two capitals. Spaced at convenient intervals along the road were stopping places where the traveler might find entertainment and a night's rest. In all there were fifty-three of these stations.

* * *

It was down this road in 1832 that a detachment of the Edo fire-brigade traveled, with the improbable duty of escorting a horse to Kyoto—a

gift from the shogun to the Emperor. One of the minor officials of the troop was Ichiyo Hiroshige, and he spent most of his time sketching. The results of these sketches appeared some time later back in Edo, when he published a series of prints showing the fifty-three stations of the Tokaido. They were an immediate success.

In the following years Hiroshige produced many series of prints, but his public always demanded new versions of the *Tokaido*. In all he produced twenty sets. This book reproduces a little-known version. That fire-brigade detachment's journey to Kyoto had a lasting effect on world art.

* * *

The medium in which Hiroshige worked was the wood-block print. In the Japan of his day the print was an ideal way of producing cheap pictures. They were known as ukiyo-e, pictures of the floating world, because they depicted the passing scene, the ephemeral world of pleasure.

This was an art of the common people. The aristocracy would probably have considered ukiyo-e beneath their dignity. (Strangely enough, it took enthusiastic Westerners to convince the Japanese that ukiyo-e was a great art form.) So it is not surprising that most of Hiroshige's prints show common people, doing everyday things. Thus, he captures the spirit of the busy Tokaido as no one else has done. He turns his

back on the "tourist view," and shows porters warming their backsides at a fire, hotel-girls trying to get travelers to stop at *their* inn, courtesans eyeing prospective customers. But always, overshadowing the human interest of the foreground, there is the magnificent scenery. Even Hiroshige's warmly observed figures have to take second place to his splendid landscapes.

It is this man—a bourgeois who liked food and drink, and occasionally has a little too much of both—who will be our guide. He's good company, and he's waiting at Nihonbashi, so let's be on our way to Kyoto along the fifty-three stations of the Tokaido. . . .

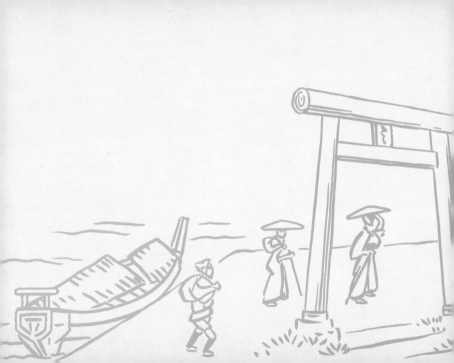

CONTENTS

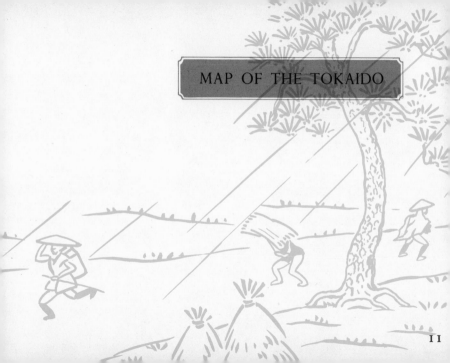

MAP OF THE TOKAIDO

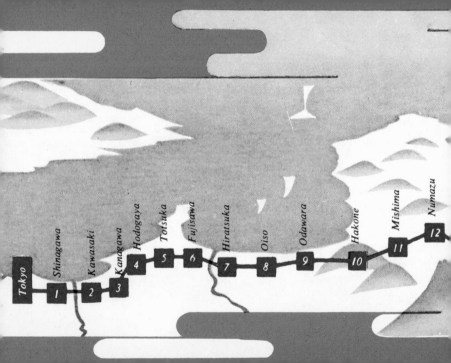

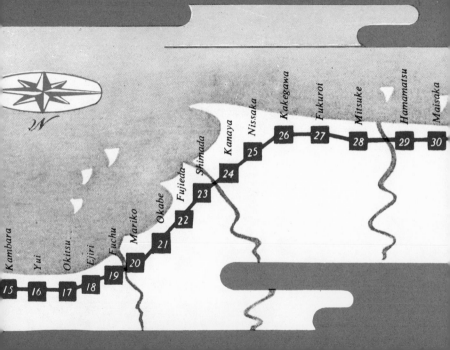

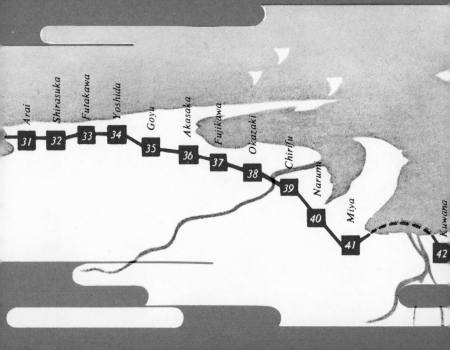

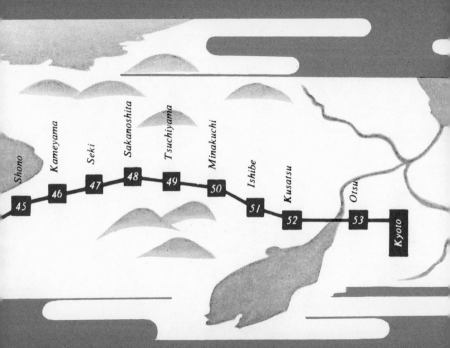

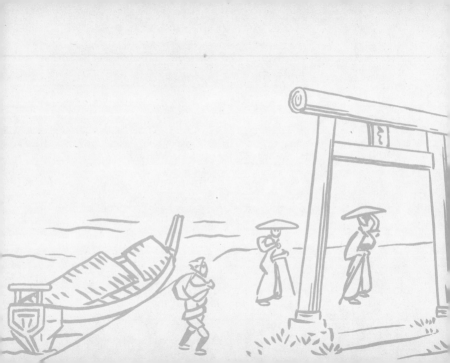

DOWN THE EMPEROR'S ROAD
WITH HIROSHIGE

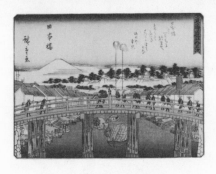

THE STARTING POINT:
NIHOMBASHI IN EDO

On a wintry morning in Edo, the vanguard of a daimyo procession crosses the bridge called Nihombashi, which marks the eastern terminus of the Tokaido. In the middle distance stand the towers and walls of Edo Castle. Far beyond them rises snow-covered Mt. Fuji.

1st Stage: SHINAGAWA

At Shinagawa, on Edo Bay, palanquin bearers, porters, travelers, and townspeople pass through a street lined with tile-roofed inns and teahouses. Large wooden or stone vats of water, surmounted by stacks of wooden buckets under a little roof, are placed outside the buildings in case of fire. Cargo and fishing boats stand in the bay, and the thatched roofs of village houses appear in the distance.

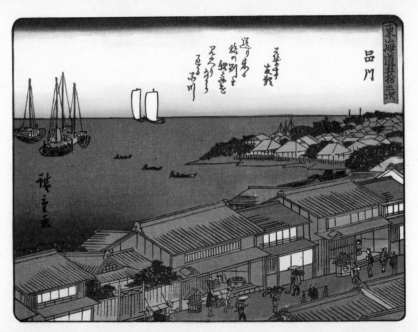

19

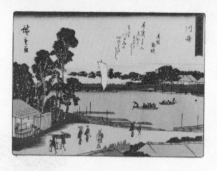

2ND STAGE: KAWASAKI

On a day in early spring, travelers cross the Rokugo River at Kawasaki by ferryboat. Among the figures outside the tea stall on the nearer shore are a samurai and his porter, two women in spring kimono, and a man carrying a large coolie hat. Timbers from an upstream lumber camp float at the edge of the river.

3RD STAGE: KANAGAWA

In the village of Kanagawa, on Edo Bay, two men stop for refreshment at a roadside stand while another entertains his young son. Porters move along the road with their cargo, and an approaching traveler carries his belongings on a pole.

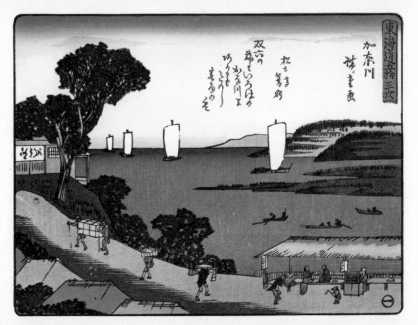

21

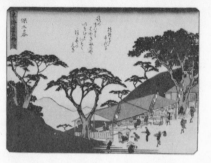

4TH STAGE: HODOGAYA

Travelers on the Tokaido relax at a festively decorated roadside teahouse in Hodogaya. While one waitress serves tea to a gentleman in his palanquin, another approaches with a tray of food. Two palanquin bearers appear to be discussing the next stage of the journey.

5TH STAGE: TOTSUKA

On the pine-bordered section of the Tokaido leading from Hodogaya to Totsuka, a porter encounters two hurrying postboys. Beyond them, two priests mount a slope in the road. The thatched roofs of Totsuka appear in the distance.

22

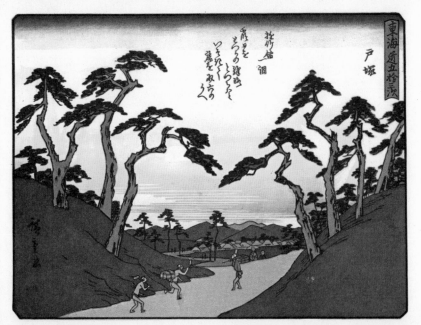

東海道五拾次

戸塚

23

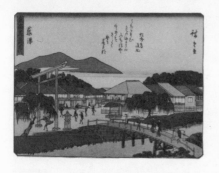

6th Stage: Fujisawa

At Fujisawa, on a day in late spring, guests at the inns enjoy the local scenery while tradesmen and other townspeople hurry about the streets. A porter enters the precincts of a shrine through its ceremonial gate, next to which stands a stone lantern. Spring mist hides the foothills of the mountains.

7th Stage: Hiratsuka

Travelers approaching Hiratsuka cross the Banyu River by ferry. One boat is used for horses and large pieces of baggage. Behind the thatch-roofed houses a grove of bamboo bends in the wind. In the distance, the white cone of Fuji rises against the sky.

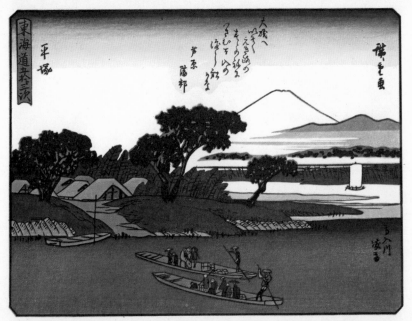

東海道五十三次

平塚

広重画

大磯へ
かかる
こゆるき浜の
まさこ路や
きぬたの音の
涼しかる覧

芦原
陽郭

25

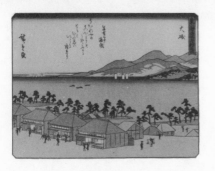

8th Stage: Oiso

In the seaside village of Oiso, the inns stand near the irregular shore, where clusters of pine trees enhance the charm of the scenery. While local vendors carry their wares through the streets, girls from the inns solicit the patronage of travelers.

9th Stage: Odawara

On the windy shore at Odawara, fishermen tug at the ropes as they haul in their catch by the dragnet method called *jibiki-ami*. Far offshore, almost beyond the horizon, fishing boats show only the tops of their sails. The ancient castle town of Odawara marks the eastern gateway of the Hakone Mountains, where Tokaido travelers complete the tenth stage of their journey from Edo to Kyoto.

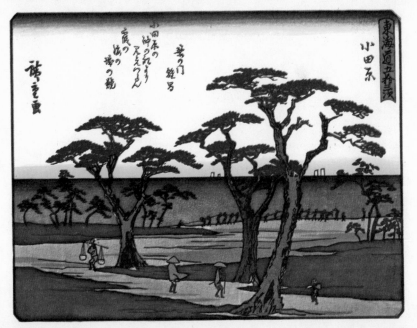

27

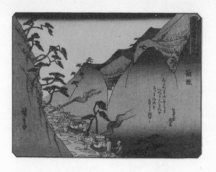

10TH STAGE: HAKONE

By the light of flaring torches, belated travelers are carried up a steep pass through the dramatic scenery of the Hakone Mountains. Despite the chill of the mountain air, three of the palanquin bearers wear only their loincloths. Across the gorge, a waterfall plunges down over shelves of rock.

11TH STAGE: MISHIMA

Having come through the mountain passes and over the winding roads of Hakone, travelers arrive at the snow-covered post station of Mishima. Mt. Fuji, gleaming with new snow, rises above the roofs of the town.

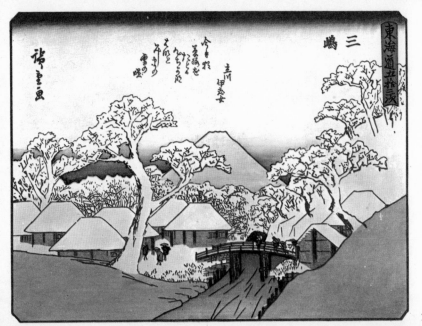

29

12TH STAGE: NUMAZU

At Numazu, where the rice fields stretch away toward the base of Mt. Fuji, a roadside teahouse offers hospitality to wayfarers on the Tokaido. A signpost and two notice boards stand at the edge of the road. The famous mountain, now quite near, dominates the horizon.

13TH STAGE: HARA

As travelers arrive late in the day at Hara, Fuji takes on a coppery glow in the light of the setting sun, and evening mists gather about its base. It is early summer, and the mountain wears only a crown of snow. The forward range is dwarfed by its soaring height.

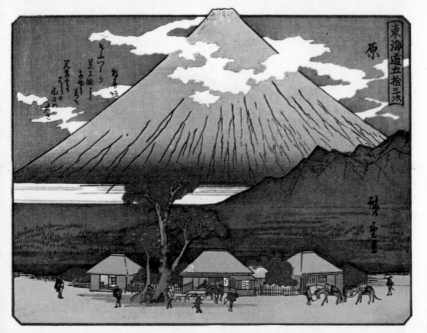

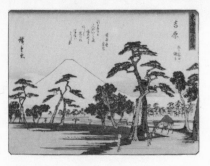

14TH STAGE: YOSHIHARA

An itinerant priest in a basket-shaped hat, a traveler and his luggage on horseback, porters, and several other wayfarers pass over the pine-bordered Tokaido on the outskirts of Yoshihara. Fuji wears a garment of winter snow. It is along this section of the road that the "peerless mountain" is seen at its finest.

15TH STAGE: KAMBARA

A well-to-do traveler in a palanquin, followed by a porter carrying lacquer baggage boxes, enters the mountain village of Kambara. In the warmth of late spring, the snow on Mt. Fuji has begun to melt, and the surrounding mountains have taken on a deeper green.

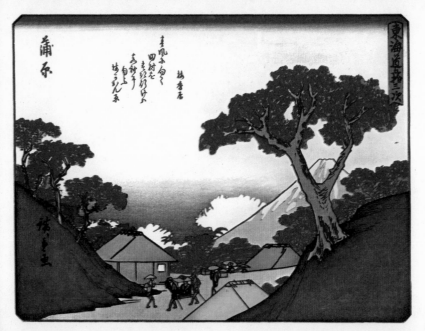

蒲原

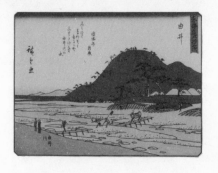

16TH STAGE: YUI

After traversing the Satta Pass, the Tokaido enters the fishing village of Yui on Suruga Bay. Here porters and racing messenger boys—one carrying a lantern on a pole—cross the shallow Yui River near where it enters the bay.

17TH STAGE: OKITSU

At Okitsu, near the harbor of Shimizu, travelers cross a stream astride the shoulders of sturdy ferrymen who wear nothing but black loincloths. Village houses nestle in the clefts of the rugged hills.

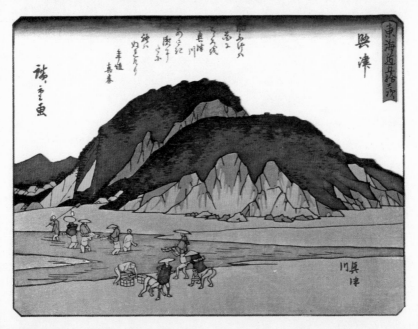

興津

35

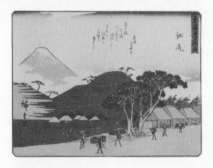

18TH STAGE: EJIRI

Three porters, two of them apparently from a nobleman's retinue, carry lacquered baggage boxes through the seashore village of Ejiri. Farther back along the road, two local vendors transport their goods in similar style. Mt. Fuji, though it has now been left behind, still lifts itself imposingly against the sky.

19TH STAGE: FUCHU

Under a brilliant full moon, the gay quarters at Fuchu become a scene of interesting activity. Geisha and their patrons, gentlemen and servants with lanterns, porters and waiters—one of them with a whole table of food—crowd the street. Several local laborers try to catch a glimpse of the goings-on inside a geisha house.

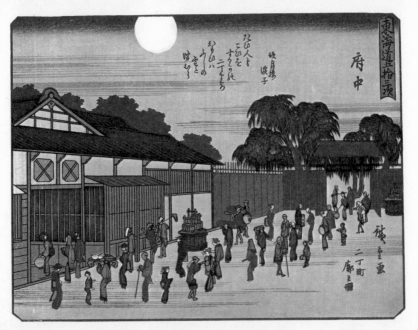

東海道五拾三次

府中

廣重画
二丁町
廓三拾

37

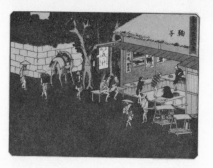

20TH STAGE: MARIKO

Newly arrived travelers and their palanquin bearers stop at one of Mariko's small inns. One palanquin bearer seems to be arguing with his customer over fees. The white sign advertises a local confection; the tan one, a brand of incense. A Kabuki poster also appears on the wall.

21ST STAGE: OKABE

In the mountain village of Okabe, palanquin bearers transport a passenger through the pass while the mistress of a teahouse serves a customer. Other travelers enjoy the scenery as they mount the steep slope. The site is Uzu-no-Yama (Mt. Uzu).

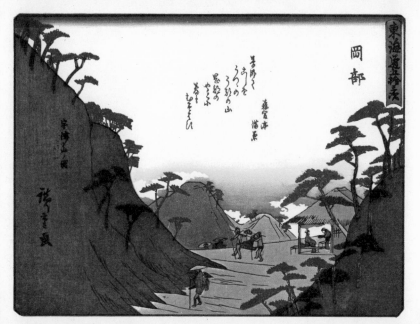

岡部

39

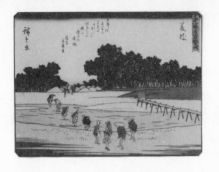

22ND STAGE: FUJIEDA

At Fujieda, travelers ford a river by the familiar method of human carrier. Several of the passengers carry their luggage done up in *furoshiki* (carrying cloths) and slung from their shoulders. A barrier at the end of the bridge seems to indicate that it is out of use for the present.

23RD STAGE: SHIMADA

Travelers approaching and leaving Shimada cross the Oi River by means of a *rendai-watashi*, a ferry consisting of platforms carried across the stream on the shoulders of porters. Here the elaborate palanquins of a daimyo and his retinue, along with his baggage and his banners, cross the river on large platforms while some members of the train are transported on smaller ones. In the remote distance, Mt. Fuji shows itself for the last time to those who are heading westward to Kyoto.

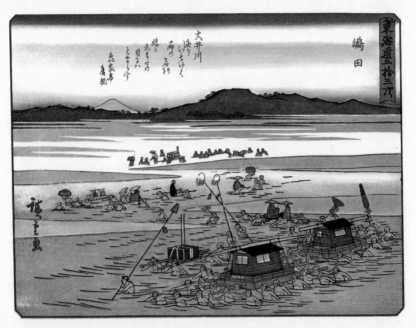

嶋田

41

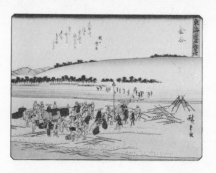

24TH STAGE: KANAYA

At another ferry on the Oi River, a daimyo and his entourage prepare to cross by means of *rendai-watashi* while porters argue about who is to carry what. Two members of the train bow in respect as they listen to instructions from their feudal lord.

25TH STAGE: NISSAKA

Hard-working porters, stripped down to their loincloths, carry their cargo through the mountain pass at Nissaka. A placard on each box announces the name of the owner. Wayside shops and teahouses have their doors open to the summer air.

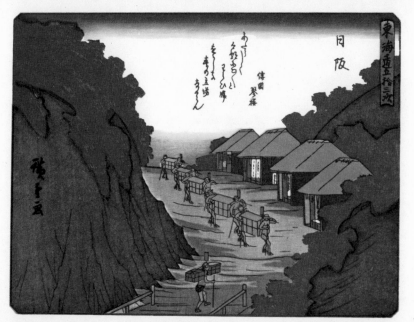

43

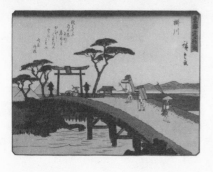

26TH STAGE: KAKEGAWA

Two Buddhist pilgrims cross the bridge into Kakegawa with their portable shrines. A third departs with a banner in his hand and a contribution box slung in front of him. Two other travelers emerge past the gate of a Shinto shrine.

27TH STAGE: FUKUROI

Horses loaded with bales of rice and other farm products, move along the Tokaido through the rural village of Fukuroi. Outside her straw-roofed cottage, a peasant woman arranges vegetables to dry. Another woman carries one of her children on her back inside a capacious jacket designed for this purpose.

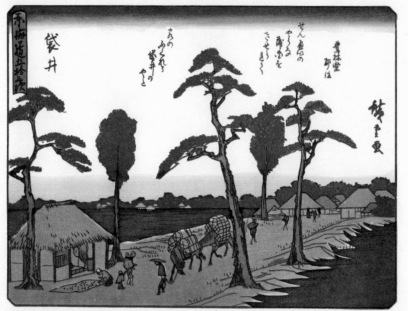

袋井

東海道五拾三次

豊林堂 卯道

あの
ふくろ井
袋井の
やど

せん
かうの
やくるの
諸味を
ささやく
ぎらく

広重画

45

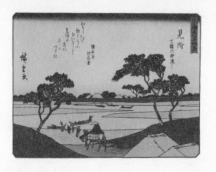

28TH STAGE: MITSUKE

The ferry over the Tenryu River at Mitsuke carries passengers in comparatively large boats, since the river in most seasons is a wide and treacherous one. Here, while some passengers wait on the shore, others are poled across the river to Hamamatsu, the next stage of the Tokaido.

29TH STAGE: HAMAMATSU

While a procession of travelers makes its way through Hamamatsu, girls from the inns are on the lookout for guests. Against a background of mountains and tall pine trees, Hamamatsu Castle stands proudly above the town.

46

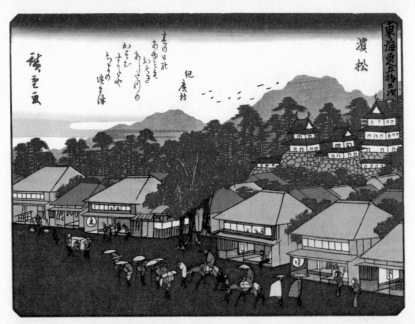

47

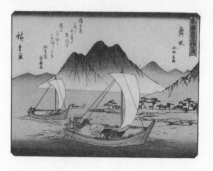

30TH STAGE: MAISAKA

At Maisaka travelers on the Tokaido cross Lake Hamana by the Imakiri Ferry. Here, while they relax on board the ferry-boats, passengers have placed their large straw hats on the thatching that serves as protection in case of bad weather.

31ST STAGE: ARAI

A daimyo and his entourage have arrived by boat at Arai to put up at a villa on the shore of Lake Hamana. Curtains bearing the nobleman's crest have been hung from the eaves and a rack set up to hold his emblems—both to show that he is in residence. As the last of his baggage is carried in, local citizens express their curiosity.

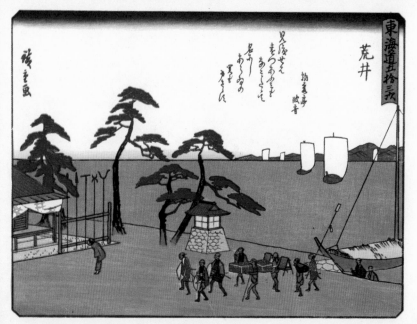

49

32ND STAGE: SHIRASUKA

At a favorite scenic spot in Shirasuka called Shiomizaka, a small Shinto shrine stands under moss-covered pine trees, and travelers enjoy the view from a thatch-roofed pavilion. A woodcutter trudges along with his load. In the rough waves offshore, only the sails of the fishing boats are visible.

33RD STAGE: FUTAGAWA

A sudden shower overtakes wayfarers on the Tokaido in Futagawa. One tries to protect himself with a straw mat, another with the roof of a small palanquin, and a third with his straw raincoat. Still others take shelter at a roadside tea stall.

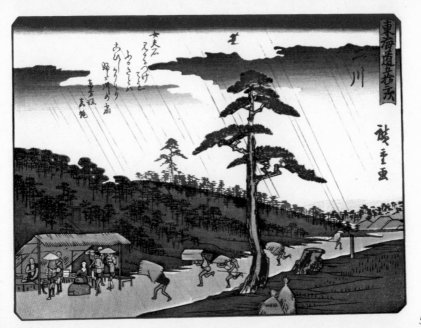

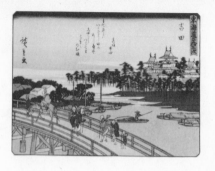

34th Stage: Yoshida

On the bridge at Yoshida, three blind musicians encounter two strolling female entertainers. Two white storehouses stand out among the other buildings of the town. Beyond the river rises Yoshida Castle, its tile roofs surmounted by mythical dolphins called *shachi*.

35th Stage: Goyu

Six robust porters carry their festively decorated cargo through the station town of Goyu. The boxes probably contain the trousseau of a bride who is on her way to her new home. The paper emblem atop the double parasol is a *gohei*, a sacred symbol of divine protection. Red and white are the colors of congratulation.

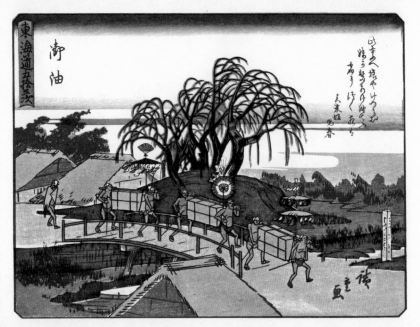

53

36TH STAGE: AKASAKA

In the early evening at Akasaka, the tempo of the day's activity slows down. The palanquin bearer and the liveryman appear to have disposed of their passengers for the day. Two laborers head for home and rest. The two stone structures serve as a kind of gateway to the town.

37TH STAGE: FUJIGAWA

Under heavily falling snow, a belated traveler and his strawcoated guide enter the hill town of Fujigawa as night comes on. Ahead of them, another man in a straw coat descends the slope, and farther along the road still another man protects himself under a half-open paper umbrella.

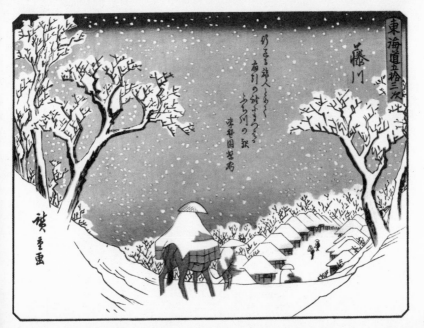

55

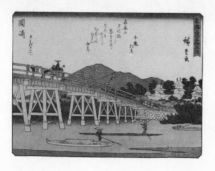

38TH STAGE: OKAZAKI

A daimyo procession starts across the Yahagi Bridge in the castle town of Okazaki. Beyond the river and the roofs of the town, the castle of the Tokugawa lifts its roofs against a background of mountains. Two lumbermen guide their logs along the river, and a boatman poles his straw-roofed craft.

39TH STAGE: CHIRIFU

While commoners bow low in enforced respect, the annual procession for presenting horses from the shogun to the emperor, passes through Chirifu on its way from Edo to Kyoto. The horses are especially caparisoned and decorated with goodluck symbols of white paper in honor of their destined owner. A porter carries a crested lacquer box. Notice boards and a square signpost stand along the road.

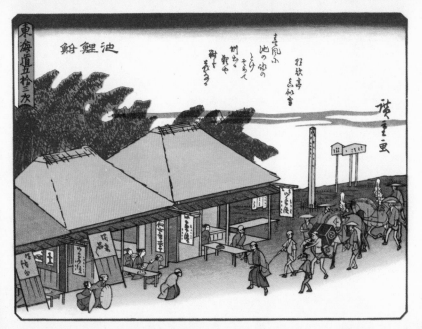

57

40TH STAGE: NARUMI

Travelers and townspeople pass through the main street of the Arimatsu district of Narumi. Here the shops display *Arimatsu shibori*, the fabric for which the district is famous. While one shopkeeper solicits patrons, another advises a woman customer concerning the making of a kimono.

41ST STAGE: MIYA

Miya is the site of the Atsuta Shrine, famous because it houses the sword called *Kusanagi-no-Tsurugi*, one of the Three Sacred Treasures of Japan. Here, at a wharf near a seaside castle, travelers arrive on a pilgrimage to the shrine.

58

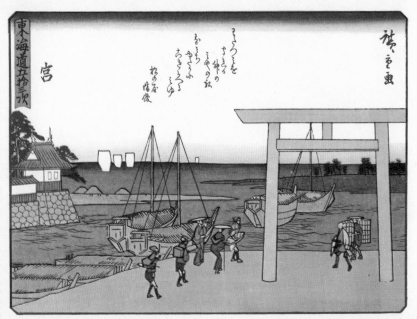

59

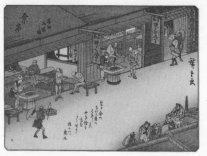

42ND STAGE: KUWANA

At the inns and restaurants of Kuwana, the specialty is *yaki-hamaguri* (baked clams), as the swinging signs announce. While guests and porters relax, waitresses bake clams on beds of glowing charcoal. The two men equipped with shovels are probably clam diggers.

43RD STAGE: YOKKAICHI

A party of pilgrims, several with contribution boxes suspended in front of them, pass through the fishing village of Yokkaichi on the Mie River. The man in white carries a large mask of a *tengu*, the legendary long-nosed goblin.

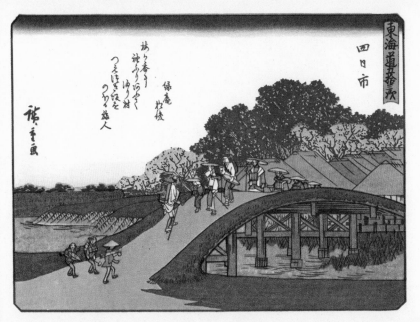

44TH STAGE: ISHIYAKUSHI

In front of the transportation agency at Ishiyakushi, a new relay of porters and horses takes over the task of carrying people and commodities to the next station. While the baggage is shifted and porters from the previous station relax, the agent and his assistants complete arrangements with two customers.

45TH STAGE: SHONO

Palanquin bearers speed their passenger along the Tokaido outside Shono as postboys dash toward the village. Several of the peasants wear straw matting to protect them from the sun while they work in the fields.

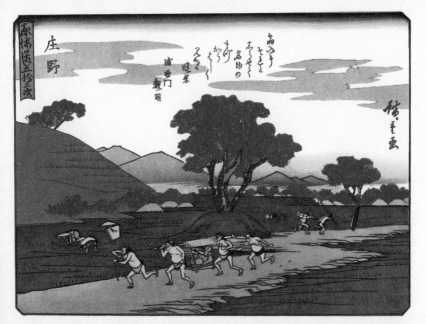

63

46th Stage: Kameyama

The castle at Kameyama, of which only a watchtower is visible here, perches high on a mountain above the village. Immense walls of hewn stone, laid without mortar, support its buildings and protect it from attack. Local tradesmen and other visitors arrive and depart through its wooden gate.

47th Stage: Seki

Considerable splendor attends the stopover of a daimyo at his temporary headquarters in Seki. Curtains of rice silk, blazoned with his family crest, have been put up to shield him from the vulgar gaze of common persons, and a placard announces his presence. His local retainers and the minor members of his retinue, except the two standard-bearers, bow in respect as his palanquin moves by. The black lacquer cases probably contain part of his luggage.

64

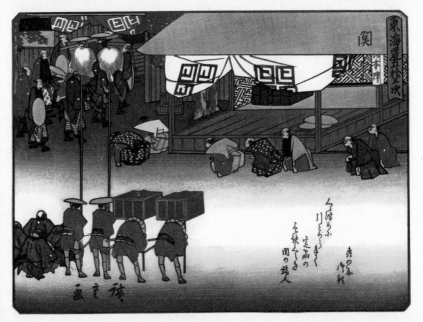

65

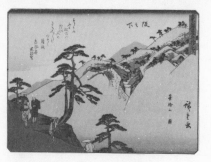

48TH STAGE: SAKANOSHITA

Near Sakanoshita, travelers stop to admire the view at Fudesuteyama, the Brush-Throwing Mountain, from which the celebrated painter Kano Mononobu is said to have hurled his brush in despair at his inability to paint the beauty of the scenery.

49TH STAGE: TSUCHIYAMA

Rain falls on the mountain village of Tsuchiyama, turning the more distant peaks into blue shadows. A local peasant wears his straw raincoat, but more affluent wayfarers protect themselves with coats of closely woven silk. The pass crosses Suzuka Mountain.

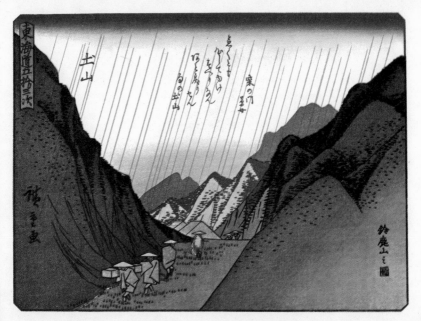

67

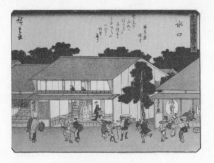

50TH STAGE: MINAKUCHI

Girls from the inns at Minakuchi forcefully solicit the patronage of male travelers while several guests look on. The names of the inns are announced on square paper lanterns, on placards and, in one case, on a round paper window. The buildings now display the Kansai (western Japan) style of architecture.

51ST STAGE: ISHIBE

At nightfall, in an inn at Ishibe, two guests enjoy a bath while a third employs the services of a blind masseur. A geisha with her hair done up in elaborate style speaks to a maid who has come to serve tea. A plum tree blooms in the garden, and the sliding paper doors are open to the air of early spring.

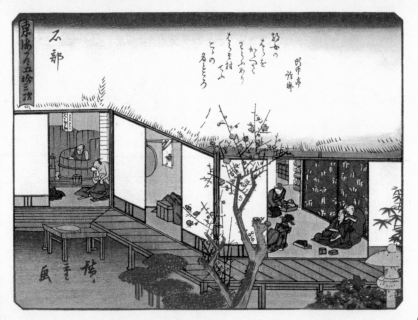

69

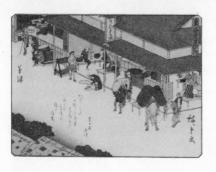

52ND STAGE: KUSATSU

A restaurant at Kusatsu enjoys good business as travelers and palanquin bearers stop for refreshment. A waitress serves food in black lacquer boxes. As three travelers prepare to resume their journey, a man repairs his straw sandal. Kyoto is no longer far off, and there is an air of anticipation among the guests.

53RD STAGE: OTSU

At Otsu, on the shore of Lake Biwa, vendors, porters, local citizens, and travelers move in a procession past a wharf and a row of shops. A small lighthouse stands at the edge of the lake. In the distance, five white stone storehouses stand out against the clustering roofs of the town.

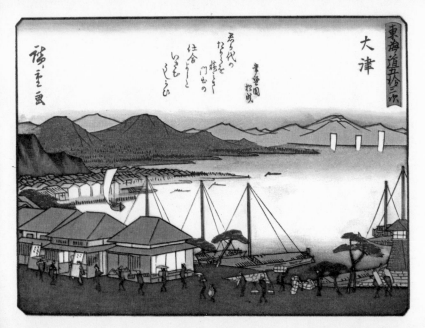

大津

東海道五拾三次

広重画

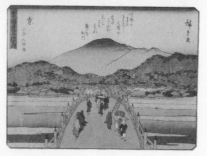

THE TERMINUS: SANJO BRIDGE IN KYOTO

At the end of the long journey from Edo, travelers cross the great Sanjo Bridge, terminus of the Tokaido in Kyoto. Geisha quarters and inns line the farther bank of the Kamo River. Temples cluster among the trees on the distant hills. In the remote background rise the high mountains that surround the ancient capital city.